ARTSOURCE™
VOLUME 2

Borders, Symbols, Holidays, & Attention Getters

Created by The Church Art Works

Youth Specialties

ZondervanPublishingHouse
Grand Rapids, Michigan
A Division of HarperCollins*Publishers*

Zondervan/Youth Specialties Books

Adventure Games
Amazing Tension Getters
ArtSource™ Volume 1: Fantastic Activities
ArtSource™ Volume 2: Borders, Symbols, Holidays, & Attention Getters
Attention Grabbers for 4th-6th Graders (Get 'Em Growing)
Called to Care
The Complete Student Missions Handbook
Creative Socials and Special Events
Divorce Recovery for Teenagers
Feeding Your Forgotten Soul (Spiritual Growth for Youth Workers)
Get 'Em Talking
Good Clean Fun
Good Clean Fun, Volume 2
Great Games for 4th-6th Graders (Get 'Em Growing)
Great Ideas for Small Youth Groups
Greatest Skits on Earth
Greatest Skits on Earth, Volume 2
Growing Up in America
High School Ministry
High School TalkSheets
Holiday Ideas for Youth Groups (Revised Edition)
Hot Talks
Ideas for Social Action
Intensive Care: Helping Teenagers in Crisis
Junior High Game Nights
Junior High Ministry
Junior High TalkSheets
The Ministry of Nurture
On-Site: 40 On-Location Programs for Youth Groups
Option Plays
Organizing Your Youth Ministry
Play It! Great Games for Groups
Quick and Easy Activities for 4th-6th Graders (Get 'Em Growing)
Super Sketches for Youth Ministry
Teaching the Bible Creatively
Teaching the Truth about Sex
Tension Getters
Tension Getters II
Unsung Heroes: How to Recruit and Train Volunteer Youth Workers
Up Close and Personal: How to Build Community in Your Youth Group
Youth Ministry Nuts & Bolts
The Youth Specialties Handbook for Great Camps and Retreats
Youth Specialties Clip Art Book
Youth Specialties Clip Art Book, Volume 2

About the YOUTHSOURCE™ Publishing Group

YOUTHSOURCE™ books, tapes, videos, and other resources pool the expertise of three of the finest youth ministry resource providers in the world:

- *Campus Life Books—publishers of the award-winning **Campus Life** magazine, who for nearly 50 years have helped high schoolers live Christian lives.*

- *Youth Specialties—serving ministers to middle school, junior high, and high school youth for over 20 years through books, magazines, and training events such as the National Youth Workers Convention.*

- *Zondervan Publishing House—one of the oldest, largest, and most respected evangelical Christian publishers in the world.*

Campus Life
465 Gundersen Dr.
Carol Stream, IL 60188
708/260-6200

Youth Specialties
1224 Greenfield Dr.
El Cajon, CA 92021
619/440-2333

Zondervan
1415 Lake Dr. S.E.
Grand Rapids, MI 49506
616/698-6900

ArtSource™ Volume 2: Borders, Symbols, Holidays, & Attention Getters

Copyright © 1991 by Youth Specialties, Inc.

Youth Specialties Books, 1224 Greenfield Drive, El Cajon, California 92021, are published by Zondervan Publishing House, 1415 Lake Drive, S.E., Grand Rapids, Michigan 49506

ISBN 0-310-53851-3

Created by David B. Adamson and J. Steven Hunt of The Church Art Works, Salem, Oregon

Printed in the United States of America

91 92 93 94 95 / ML / 10 9 8 7 6 5 4 3 2 1

TABLE OF

CONTENTS

INTRODUCTION **8**

TIPS FROM THE PROS **10**

BRAINSTORM FORM **14**

BORDERS **15**

SYMBOLS **51**

HOLIDAYS **69**

ATTENTION GETTERS **85**

INDEX **95**

Enter a New Era of Creativity
With ArtSource™ Computer Clip Art

The clip art you see in this book is also available on computer! Youth Specialties and The Church Art Works invite you to try computer clip art—high-resolution art on computer disks for use with the most popular page layout programs. Each illustration is digitized into its own file for easy manipulation—stretching, squeezing, enlarging, and reducing.

Enjoy the advantages of creating the electronic way—with ArtSource™ computer clip art.

COLLECT THE ENTIRE ARTSOURCE™ COMPUTER CLIP ART SERIES:
 Volume 1—Fantastic Activities
 Volume 2—Borders, Symbols, Holidays, & Attention Getters
 Volume 3—Sports
 Volume 4—Phrases & Verses
 Volume 5—Amazing Oddities & Appalling Images
 Volume 6—Spiritual Topics

SPECIFICATIONS:
***MACINTOSH**® : Accessible through page layout programs including PageMaker®, ReadySetGo!™, and Quark XPress™. Minimum recommended memory requirement is 640K and a hard drive. Art comes on DS/DD disks. Also accessible with Aldus Freehand® and Adobe Illustrator® for modifications.*
***IBM**® **AND COMPATIBLES:** Accessible through page layout programs including PageMaker®, Ventura Publisher®, WordPerfect® 5.0 and 5.1 as well as other programs supporting TIF. Minimum memory requirement for importing images into your page layout programs is 640K and a hard drive. Art comes on 3 1/2" DS/DD disks and 5 1/4" DS/DD floppy disks.*

ACKNOWLEDGMENTS

Thanks to the hundreds of youth ministers who have submitted ideas for these illustrations. Thanks also to these artists who have contributed to the books:

Michelle Baggett
Bruce Day
Chris England
Tom Finley
Corbin Hillam
Mark "Lindy" Lindelius
Dan Pegoda

Also, thanks to our team at The Church Art Works:

Kelley Adamson
Michelle Baggett
Mike Bartlett
Bruce Bottorff
Jeff Sharpton
Beth Weld

And finally, thanks to our wives, Kelley and Kathy, for allowing us to work evenings and weekends to see this dream come to reality.

INTRODUCTION

We've designed ArtSource™ to be a quick and complete sourcebook for your youth program promotions. It contains art from The Church Art Works' extensive files of ministry clip art, as well as from several other contributing artists. The art is arranged by subject and will cover most activities you'll be involved in during the year. Future volumes will supply new subjects as well as additional art for the current subjects.

We want this book and others in the series to be a real asset to your ministry. You can help us with ideas for more clip art by using the Brainstorm Form on page 14. When you submit your ideas to us, you keep the creativity flowing. We hope our efforts will assist all of you in your ministries as you work for positive growth in your students.

LET'S BE CREATIVE!

This book gives you the chance to be creative, pumping life into your promotions and creating excitement in your group. Just follow these four easy steps:

1. *CREATE AN EXCITING IDEA.* Planning and scheduling your youth group activities in advance is essential. But don't stop there. Hold separate brainstorm sessions to allow time for creativity to blossom. Creative ideas don't come easily in a "board meeting" format, so get away to a wacky place or neutral territory with a few "crazy" idea people. The clip art contained in this book should inspire some ideas you may not have considered. Once the ideas are on paper, sort them out and plan the logistics later. This will help you break away from the pressures of your everyday work and will keep your ideas fresh.

2. *CREATE AN EXCITING MESSAGE.* When you prepare your information, think like a kid. Don't be trapped into just listing the "time, date, and place." To expand your thinking, we've shown you four examples of possible layouts on pages 12 and 13.

BASIC STEPS IN PREPARING PRINTED MATERIALS

Helpful tools that will make your job easier are a pair of scissors, an x-acto (craft) knife, a ruler, a light blue pencil (nonreproducing) for layout, rubber cement, glue stick or wax for adhesive, tape, black felt-tip pens of various widths, a t-square, triangles, sheets of transfer lettering (rub-on type), a technical pen, and a drafting table or drawing board. All of these tools are available from your local art/ drafting store.

Photocopy or cut out pieces of art from this book for your project. You can reduce it or enlarge it on a photocopier. Choose art that fits your subject.

Plan your layout. Sketch (on a separate piece of paper) where you want art and where you want copy (headlines and details). See pages 10-13 for ideas.

Use felt-tip pens, a type-writer, or a desktop computer to set your type. Assemble this in combination with the clip art and paste it on a clean white sheet or card for your "master."

Copy the master to reproduce as many printed pieces as you need for your event. Copying can be done on your photocopier or at a print shop.

3. *CREATE AN EXCITING LOOK. Think beyond the "normal" approach in laying out information for an announcement or flyer. Young people love seeing the unusual. Instead of aligning things straight, place them at an angle on the page. If you're comfortable with small type, think BIG type. And if you're tempted to illustrate your message with a normal-looking teenager (whatever that is), use a fat hippo instead!*

As you begin your layout of a flyer or poster, grab a nice big piece of paper, a pencil, and a few pieces of clip art . One way to be sure you don't get trapped into the same old layout procedure is to lay the clip art on your layout sheet first. Let it be as big as you want, just so that it's fun and has impact. Enlarge it if necessary, then work the rest of the copy and headlines around the art. This will create some unusual shapes and column widths. It'll be easier and more fun!

You can also use the paper and pencil to roughly sketch out small (2"-3") layout options. Explore radically different layouts of the various elements in your piece. For example, in one sketch the art may be huge with small support-ing type; in another, the type may be huge with the art sized fairly small. You have many different options with the same piece of clip art — such as repeating it several times for a border effect.

4. *CREATE AN EXCITING ATTITUDE. After you've committed your plans to God, promoting your event is the first step toward contacting those you want to reach. Stretch yourself and strive for the very best. This new attitude will be reflected in your work. Others will sense your desire for creativity and profession-alism, and the enthusiasm will spread. As more people become involved in the project, you'll also stretch them. The results will be exciting, as the "team" begins to focus on a worthwhile goal.*

In the following pages we've put words into action by giving you creative samples of ways to use clip art. Use these ideas to launch your own exciting promotional pieces. Have fun!

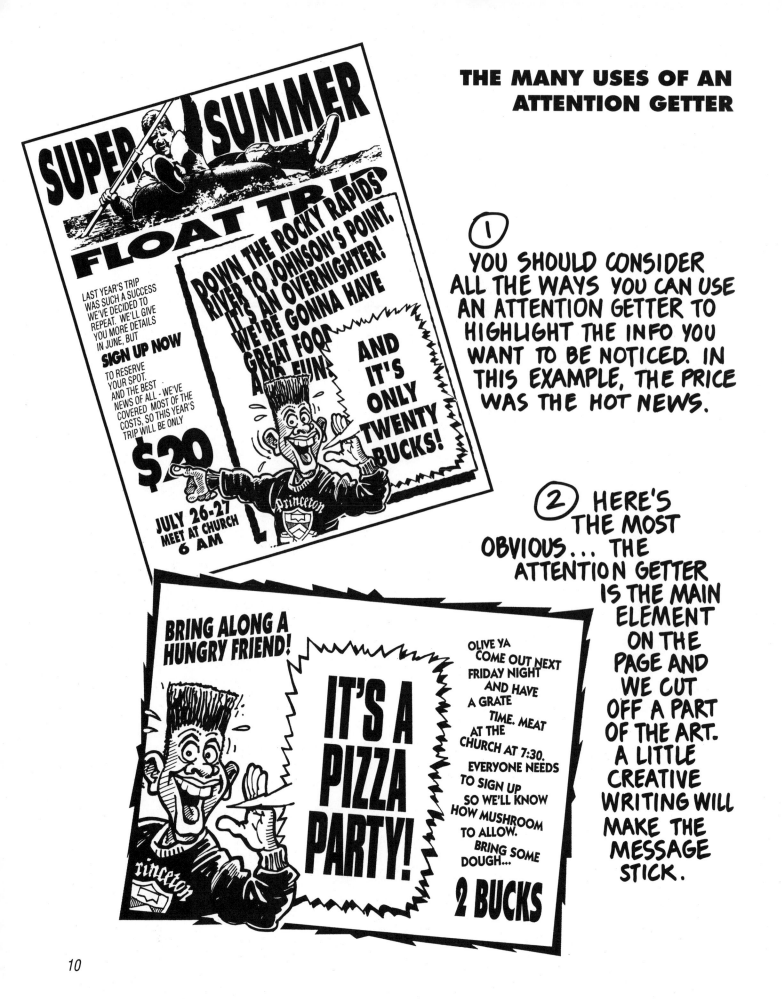

① YOU SHOULD CONSIDER ALL THE WAYS YOU CAN USE AN ATTENTION GETTER TO HIGHLIGHT THE INFO YOU WANT TO BE NOTICED. IN THIS EXAMPLE, THE PRICE WAS THE HOT NEWS.

② HERE'S THE MOST OBVIOUS... THE ATTENTION GETTER IS THE MAIN ELEMENT ON THE PAGE AND WE CUT OFF A PART OF THE ART. A LITTLE CREATIVE WRITING WILL MAKE THE MESSAGE STICK.

③ HERE'S A LAYOUT WHERE WE USED THE ART BLOWN UP HUGE, AND WE CUT OUT MUCH OF THE ART. WE ALSO REDUCED THE WORD BUBBLE A LITTLE SO THAT WE COULD MAKE THE FACE BIGGER.

④ HERE'S THE PICTURE USED IN ITS ENTIRETY WITH DIFFERENT BORDERS FOR MORE IMPACT.

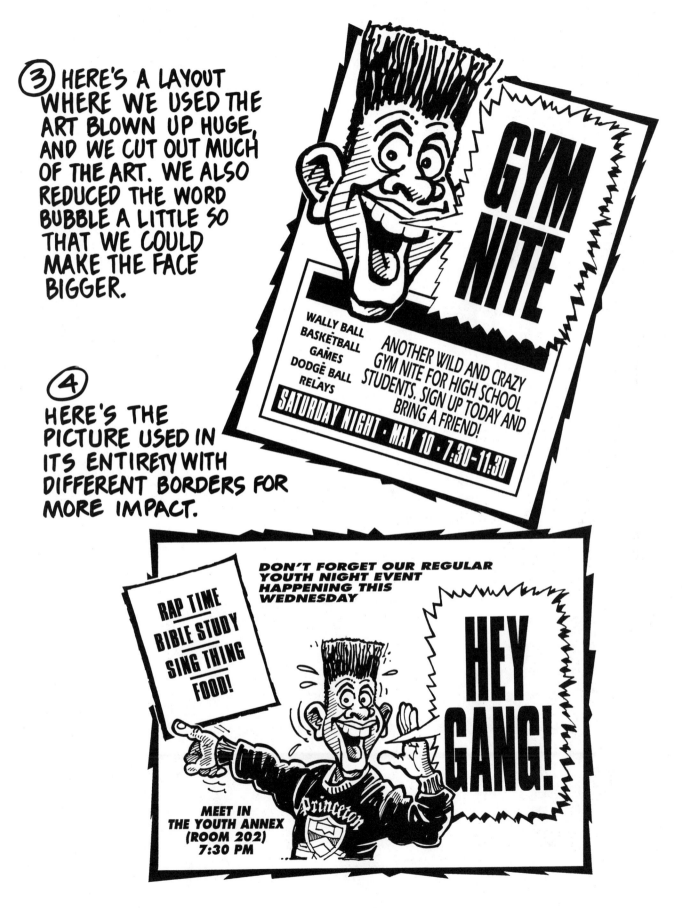

EIGHT WAYS TO GET MO E MILEAGE OUT OF A BORDER

Be creative with the borders in this book. You can do a lot with a copier and some scissors!

① DRAW A HEAVY LINE BOX ON A CLEAN WHITE PIECE OF PAPER. CUT IT OUT AND LAY IT OVER YOUR BORDER PAGE. THIS CREATES A SECONDARY INNER BORDER.

② THIS LAYOUT REQUIRES USE OF TORN BLACK PAPER. (YOU CAN MAKE SOME BLACK PAPER BY TRIPPING YOUR COPIER WITH THE LID UP.) THEN TEAR THE PAPER INTO SMALL PIECES TO CREATE WORD PANELS.

③ CUT UP A COPY OF YOUR BORDER AND PASTE IT BACK TOGETHER (MINUS THE MIDDLE SECTION) TO CREATE A TALL, NARROW BORDER.

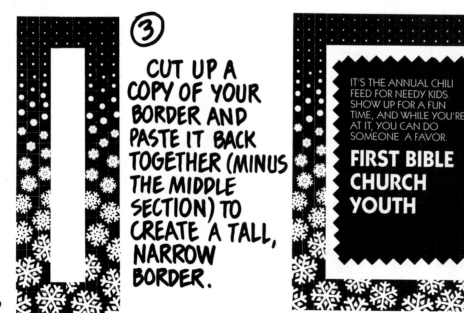

IT'S THE ANNUAL CHILI FEED FOR NEEDY KIDS. SHOW UP FOR A FUN TIME, AND WHILE YOU'RE AT IT, YOU CAN DO SOMEONE A FAVOR.

FIRST BIBLE CHURCH YOUTH

④ USE PINKING SHEARS TO CUT OUT A BLACK PAPER "CENTER" AND PLACE IT INSIDE YOUR BORDER. YOU CAN ALSO PLACE IT AT AN ANGLE AS SHOWN IN EXAMPLE ①.

 5

AFTER INSETTING A PIECE OF BLACK (OR TONED SCREEN) PAPER, ENLARGE SECTIONS OF THE BORDER PATTERN ON YOUR COPIER AND PLACE INTO THE PAGE.

6 COPY THE BORDERS A FEW TIMES — POSSIBLY IN DIFFERENT SIZES — AND ARRANGE THEM ON THE PAGE FOR SEVERAL PANELS OF INFORMATION.

7 USE A SMALL REDUCTION OF THE BORDER AS A PANEL FOR THE HEADLINE.

8 DRAW SEVERAL GEOMETRIC SHAPES (WITH A FELT-TIP PEN) ON A WHITE PIECE OF PAPER. CUT THEM OUT, AND ARRANGE THEM ON THE BORDER SHEET. FILL THEM WITH YOUR MESSAGE.

SNOW TRIP *Sign Up*

We want to serve you! Send us your ideas so that we can draw them
for future books to assist you in your ministry.

Name_____

Church or Ministry_____

Address_____

City_____

State_____Zip_____

Phone_____

B R A I N S T O R M F O R M

Here are some ideas I'd like to see in future books:

Food Fun:

Fundraisers:

Group Stuff:

Music:

Summer:

Winter:

Copy and send to: The Church Art Works • 875 High Street NE • Salem, Oregon 97301 • (503) 370-9377 • FAX (503) 362-5231

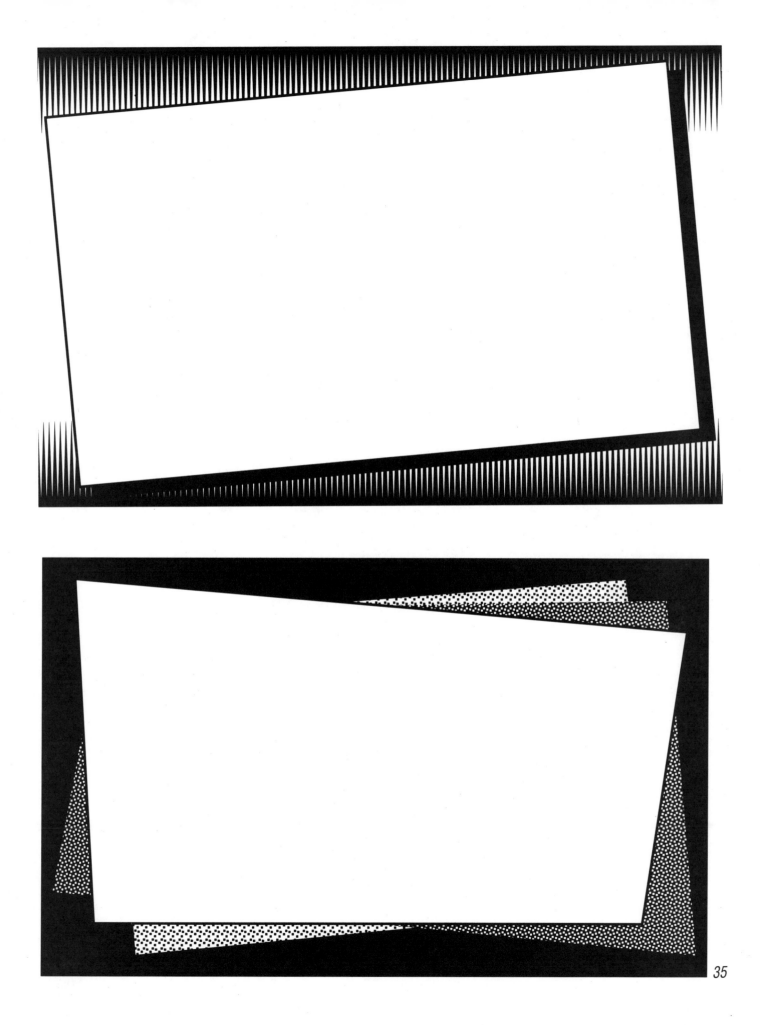

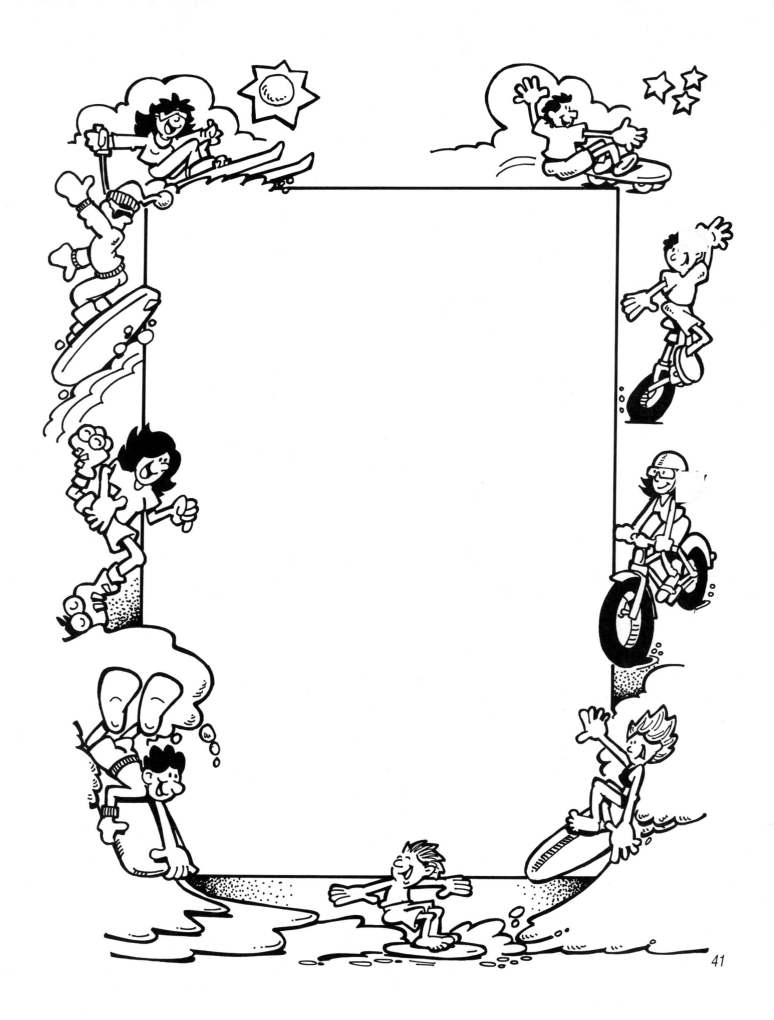

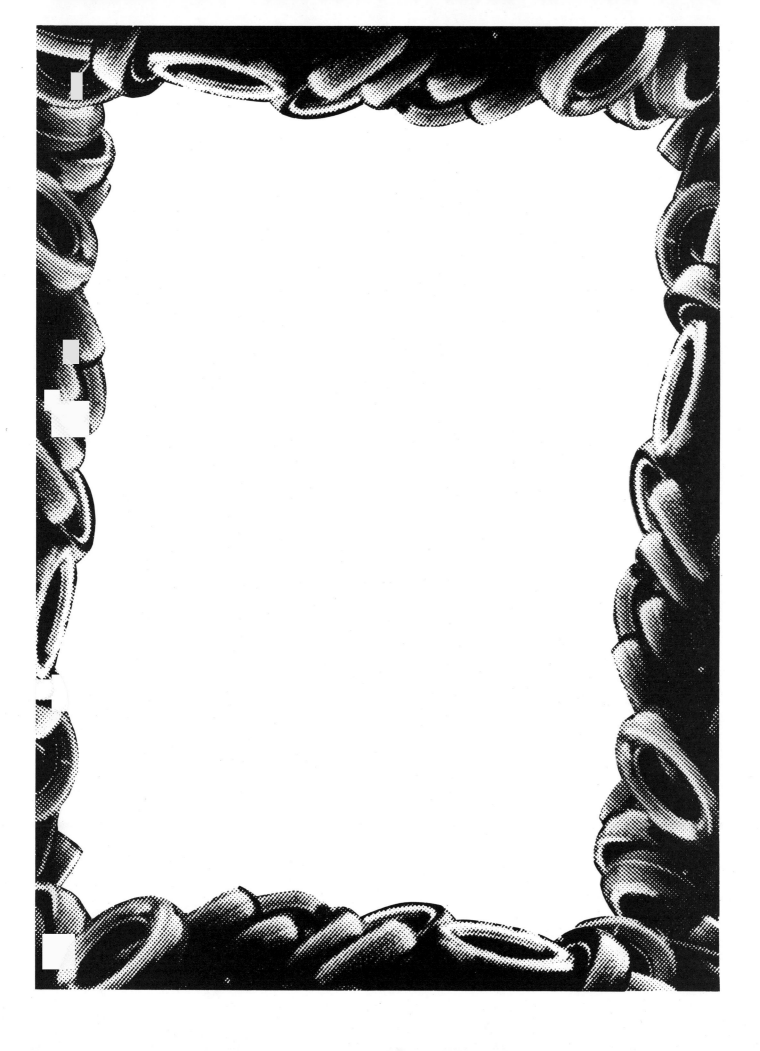

PHONE DIRECTORY

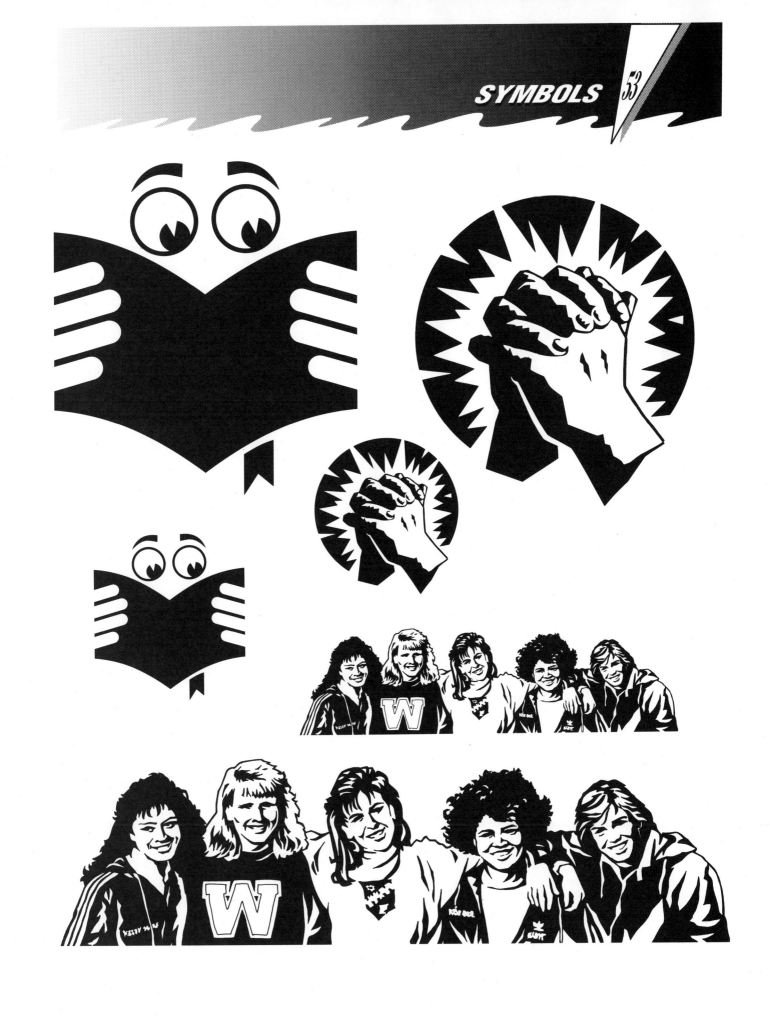

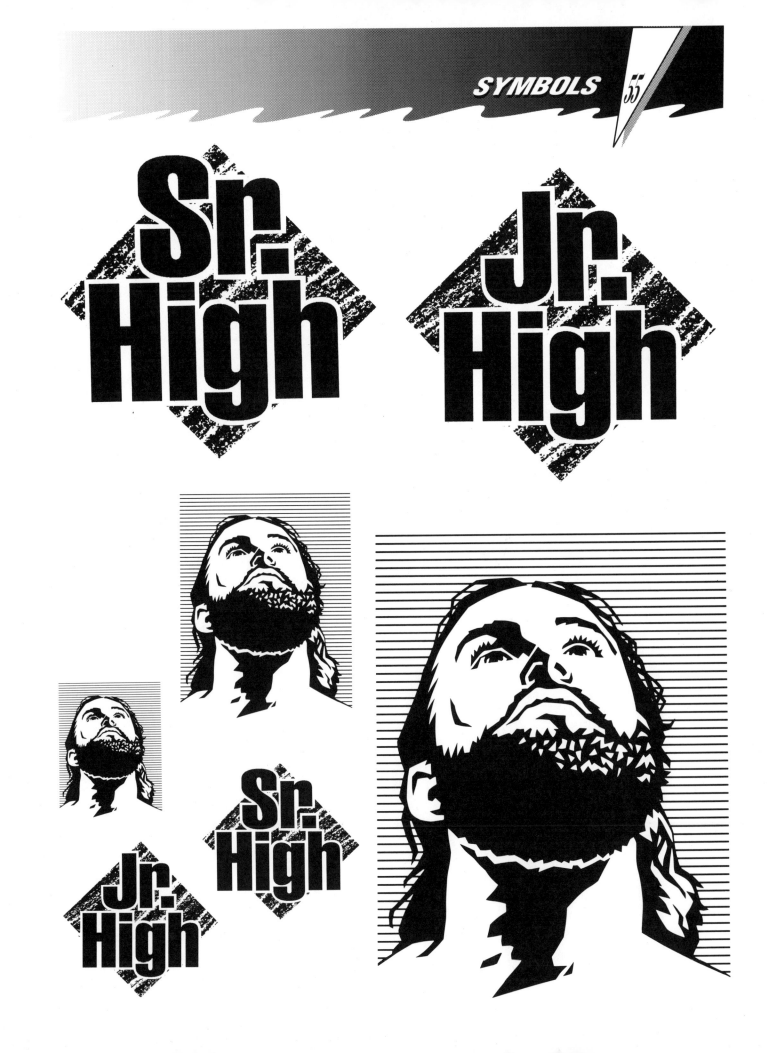

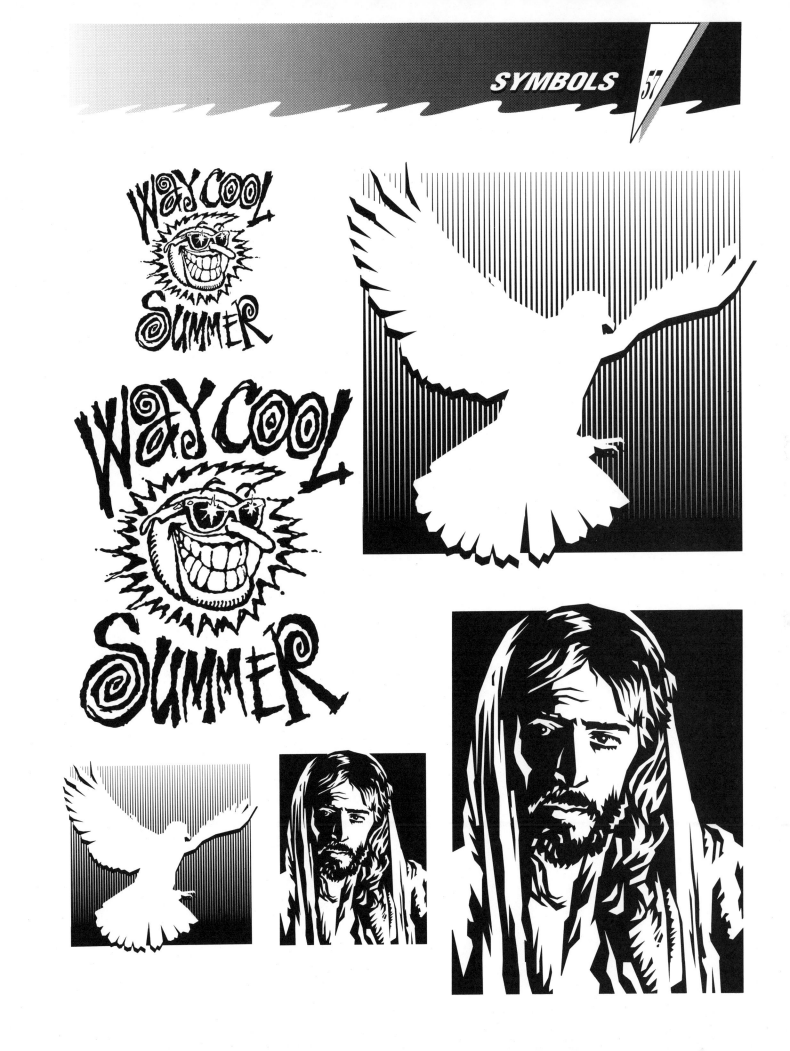

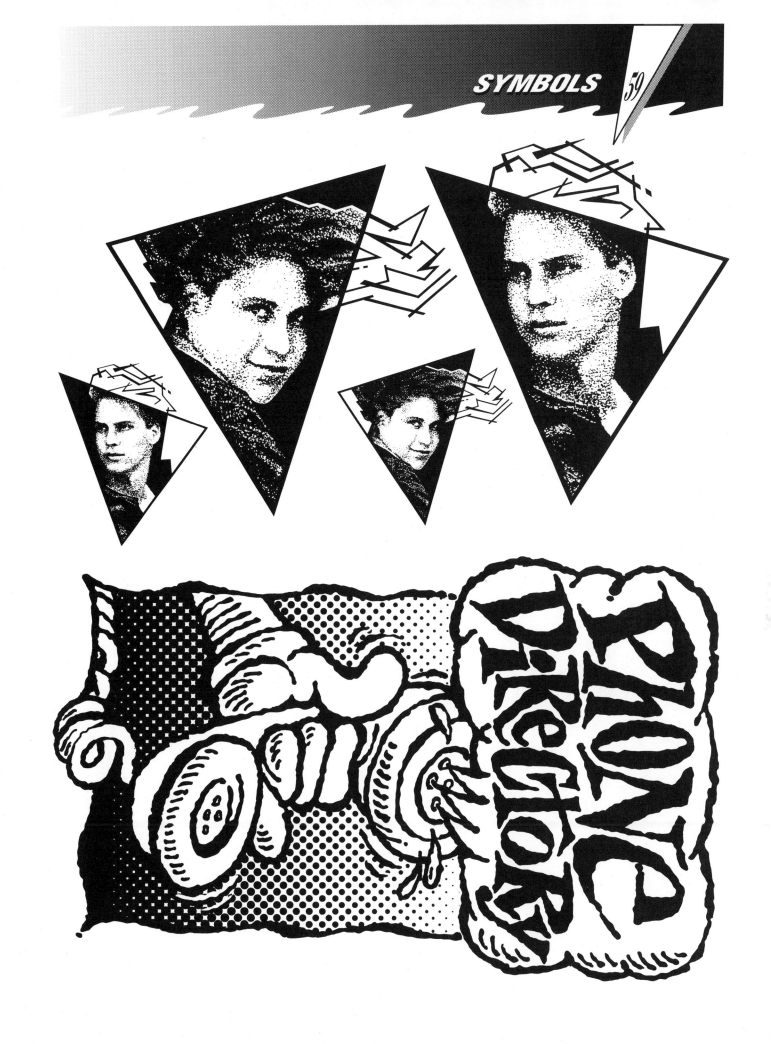

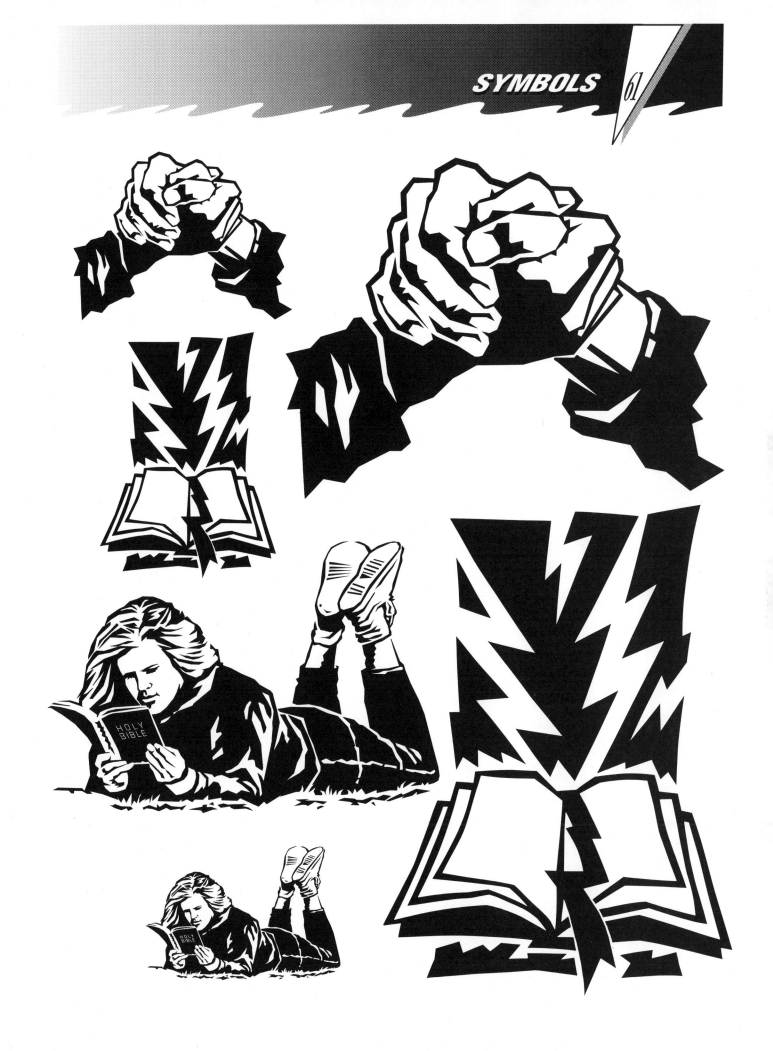

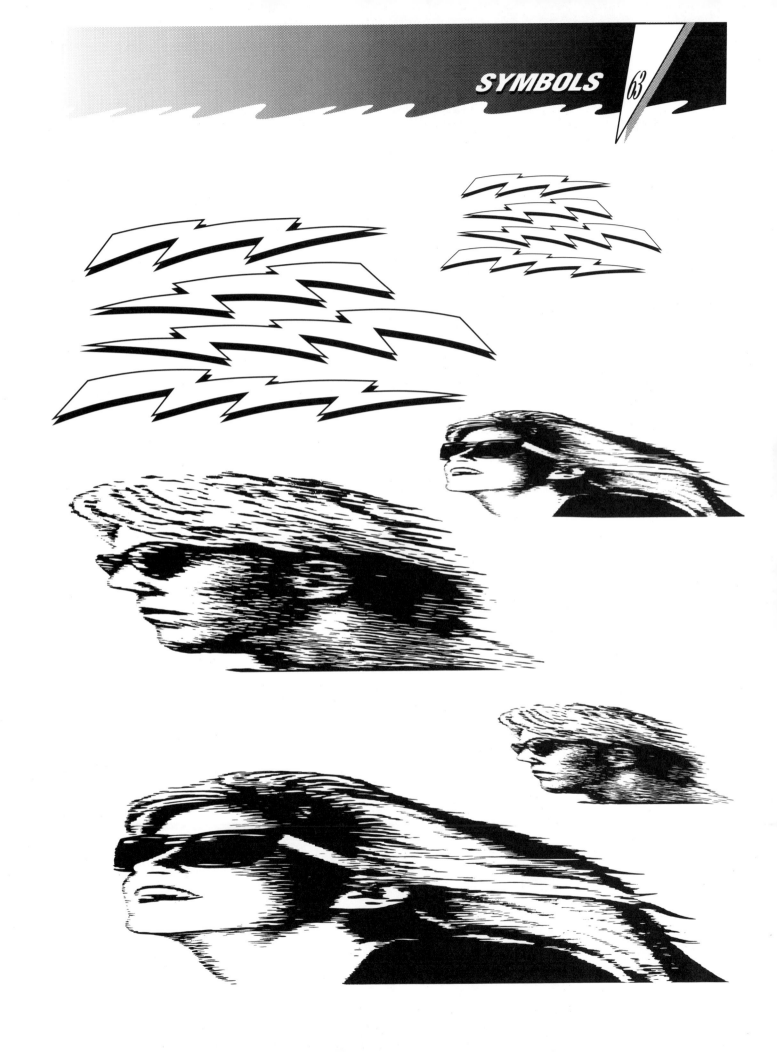

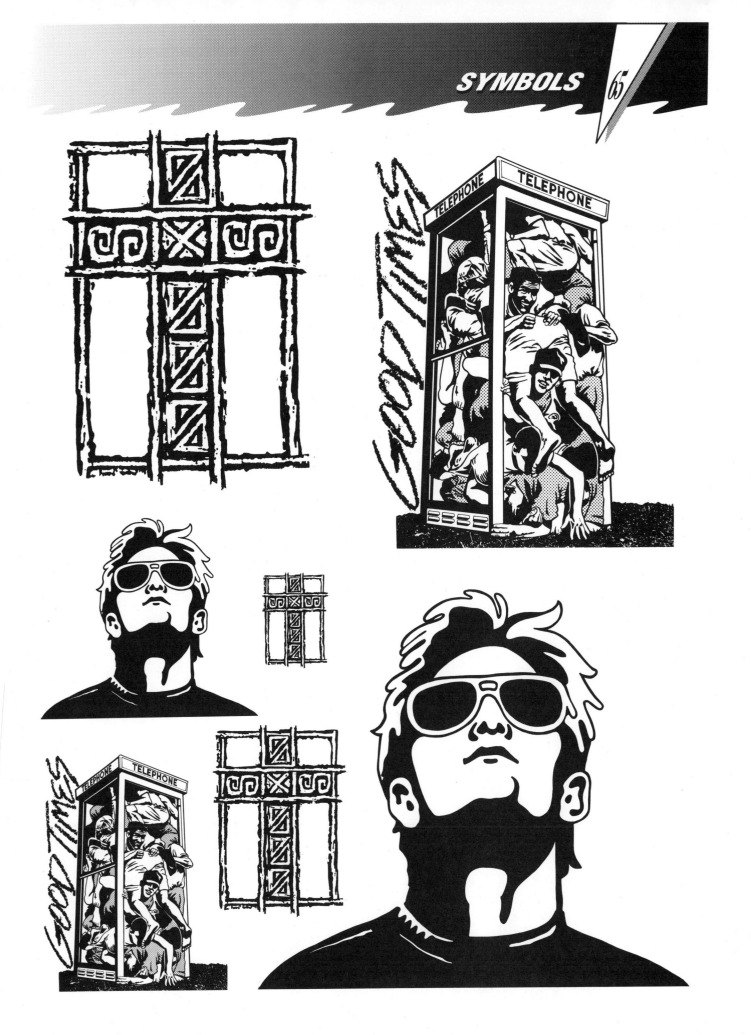

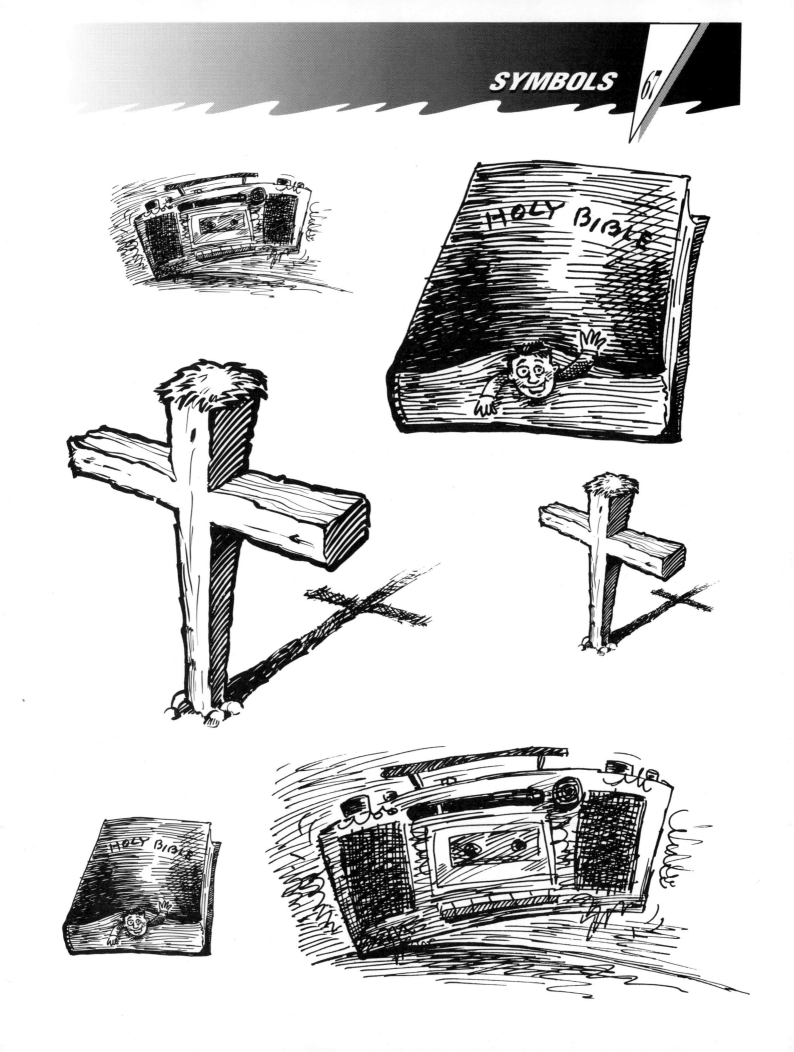

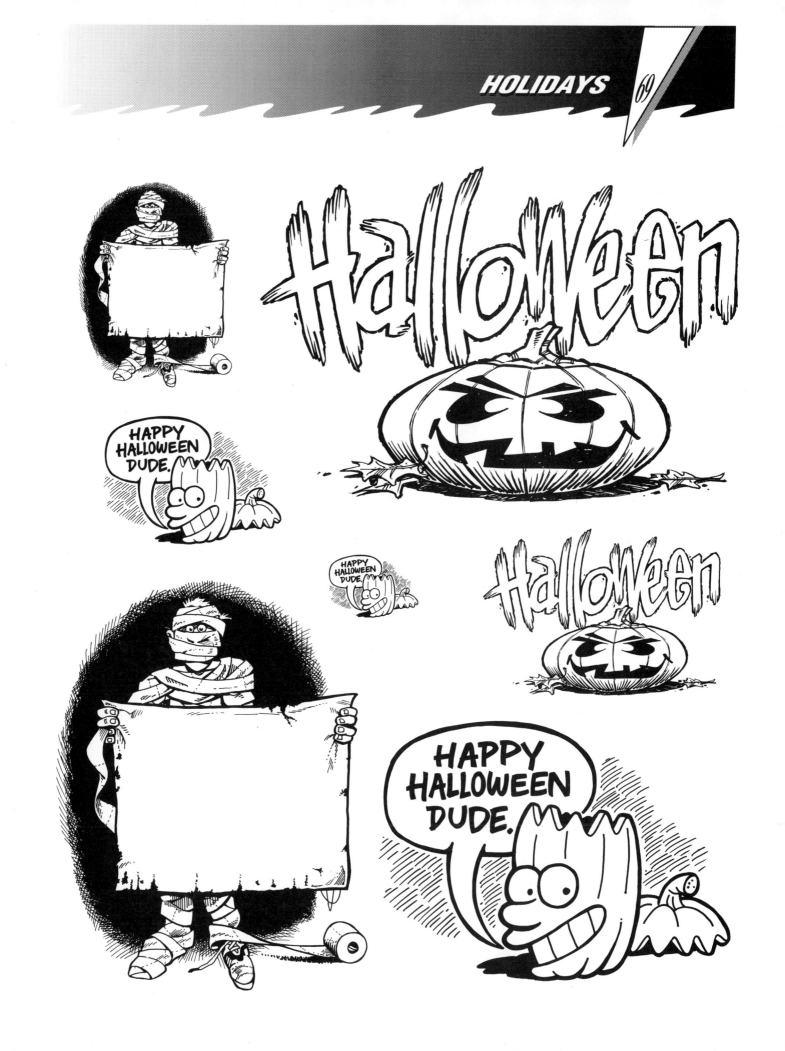

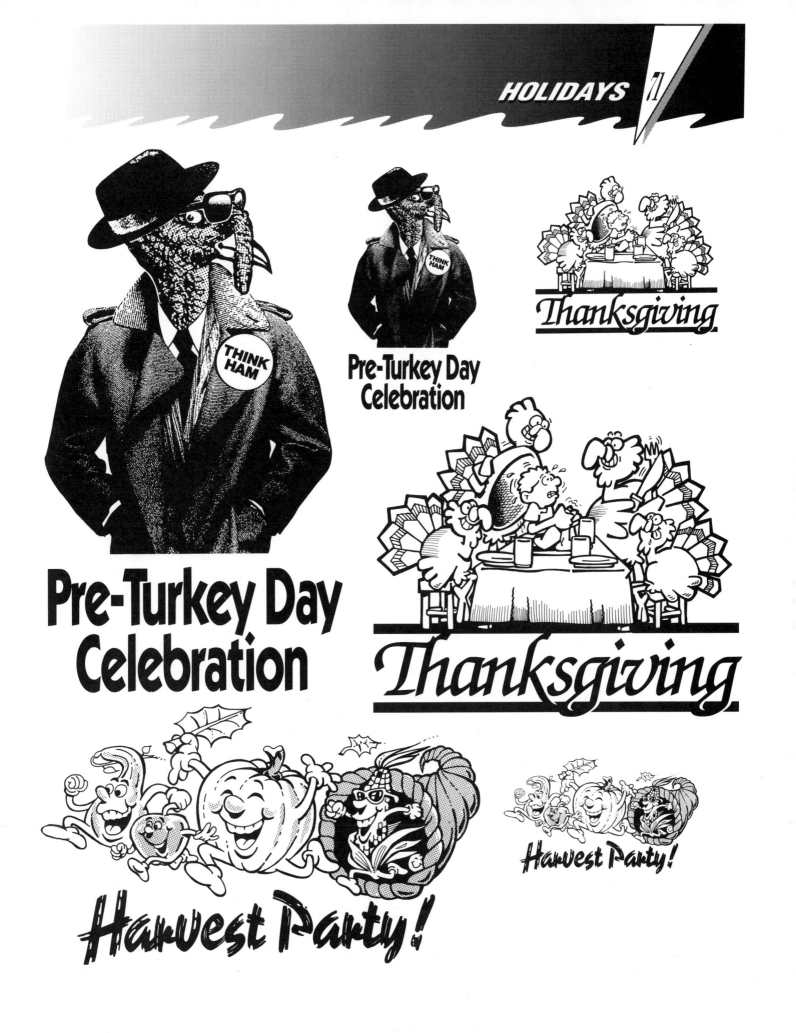

Pre-Turkey Day
Celebration

Thanksgiving

Pre-Turkey Day
Celebration

Thanksgiving

Harvest Party!

Harvest Party!

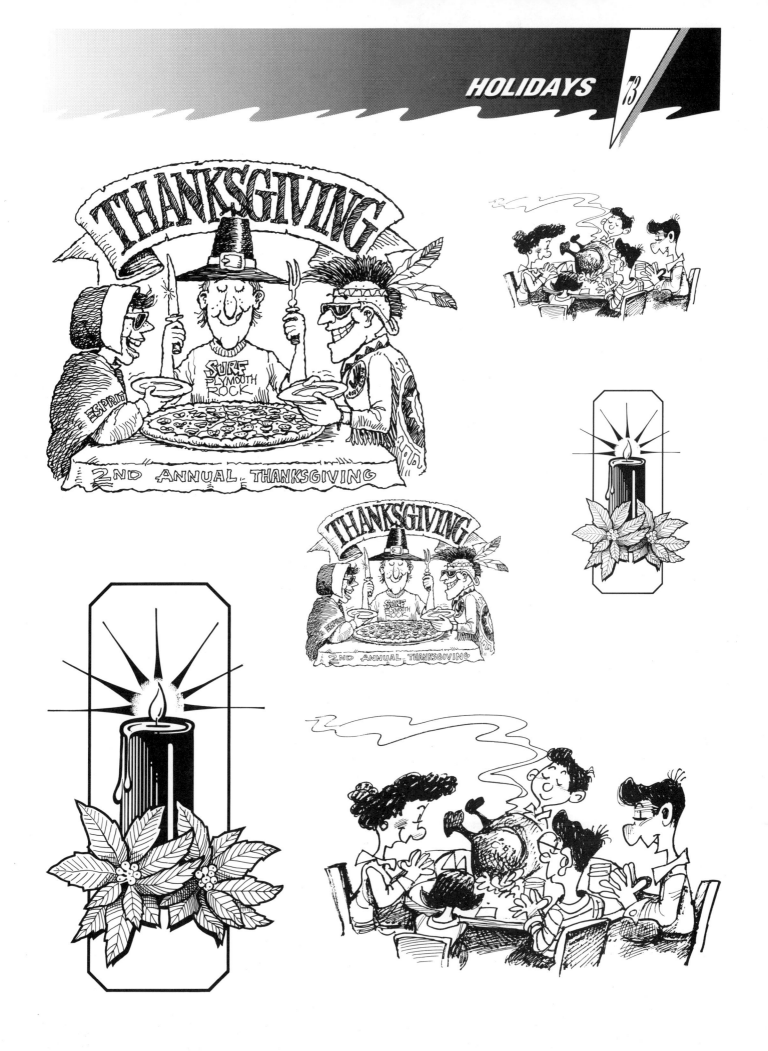

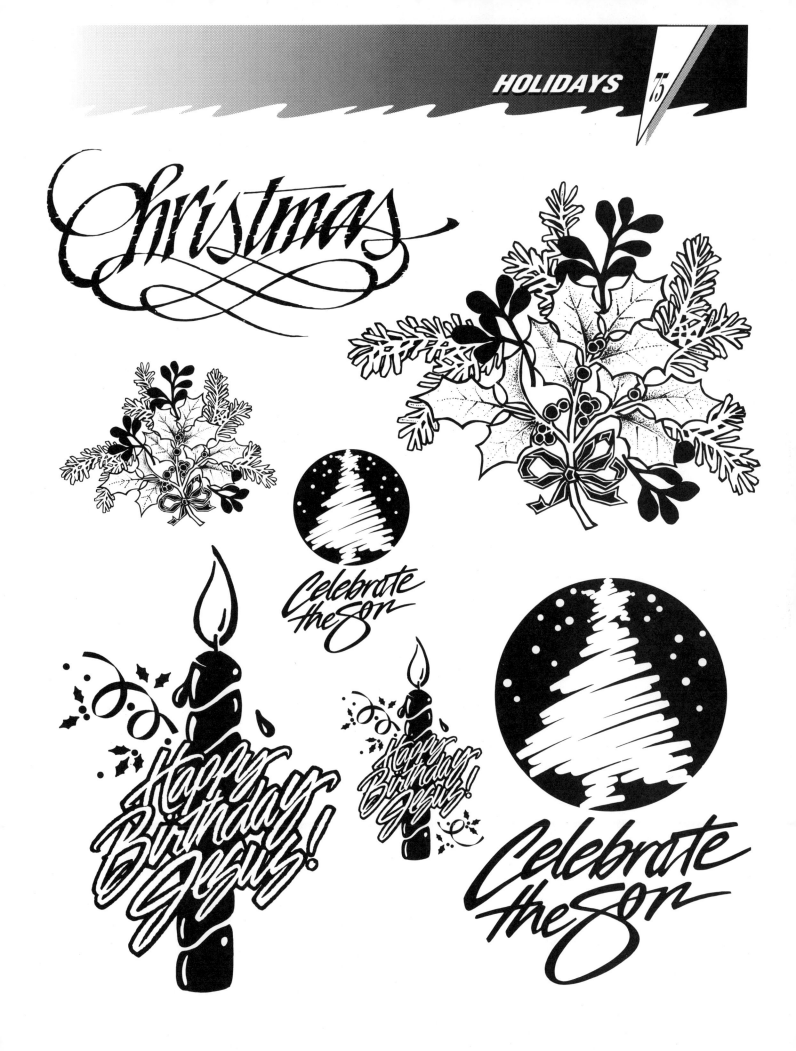

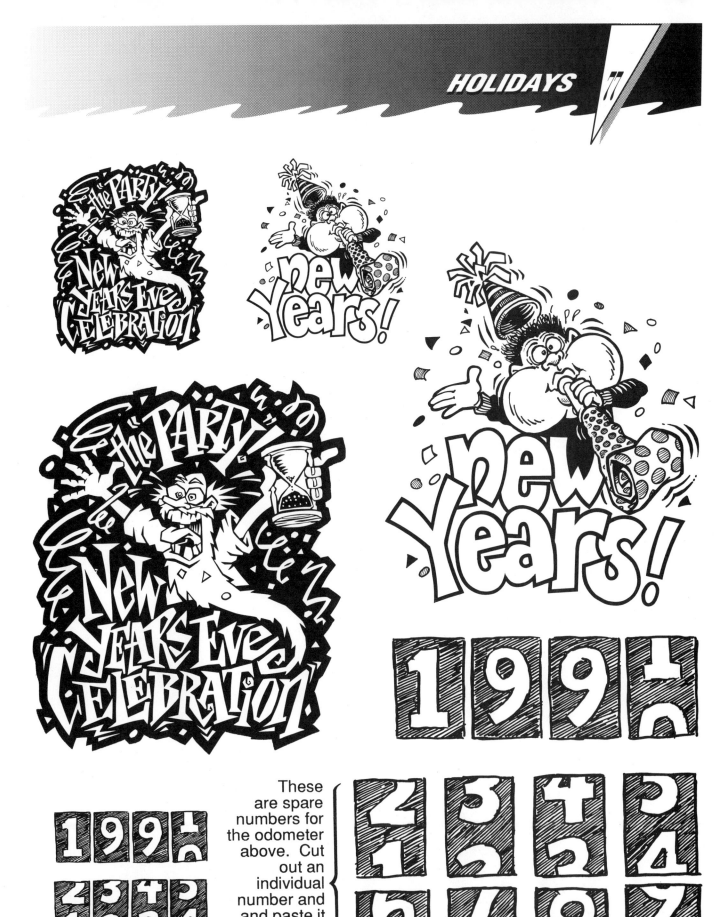

These are spare numbers for the odometer above. Cut out an individual number and and paste it over the final box on the odometer above.

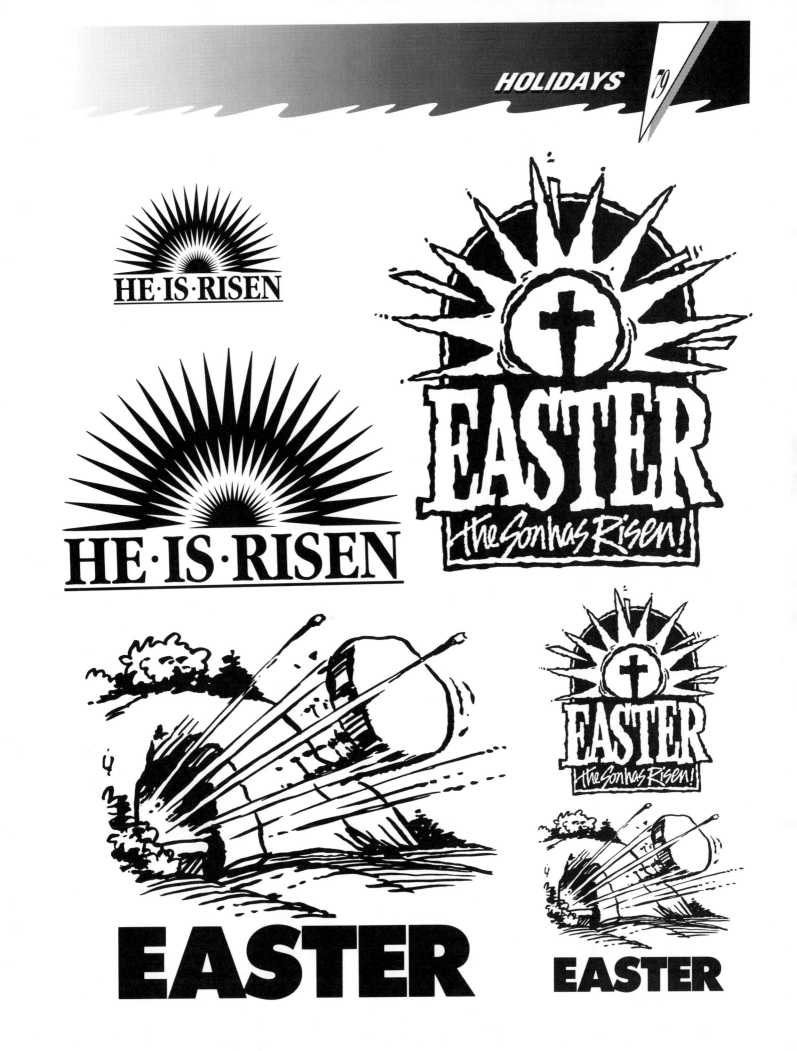

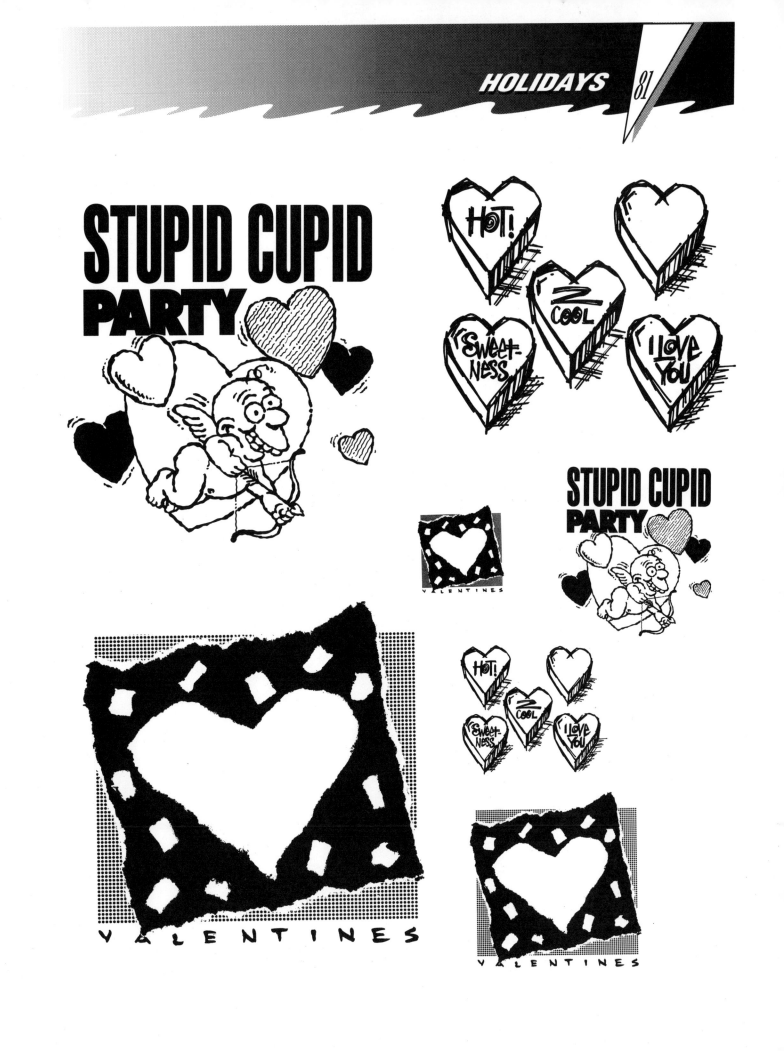

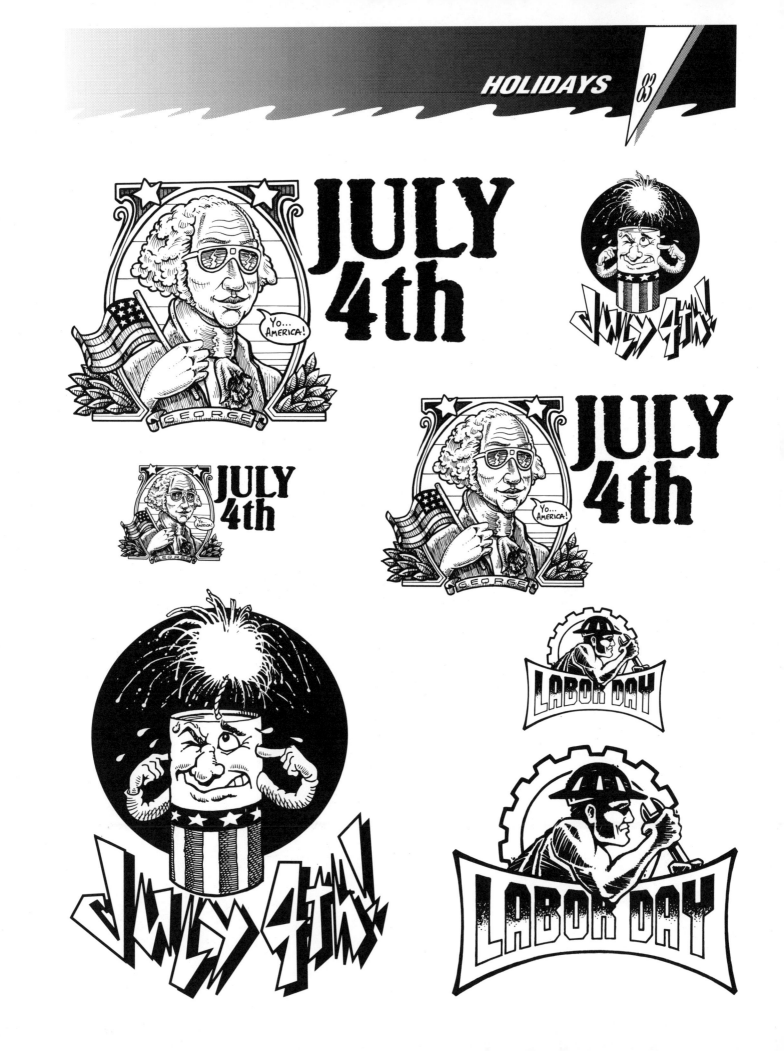

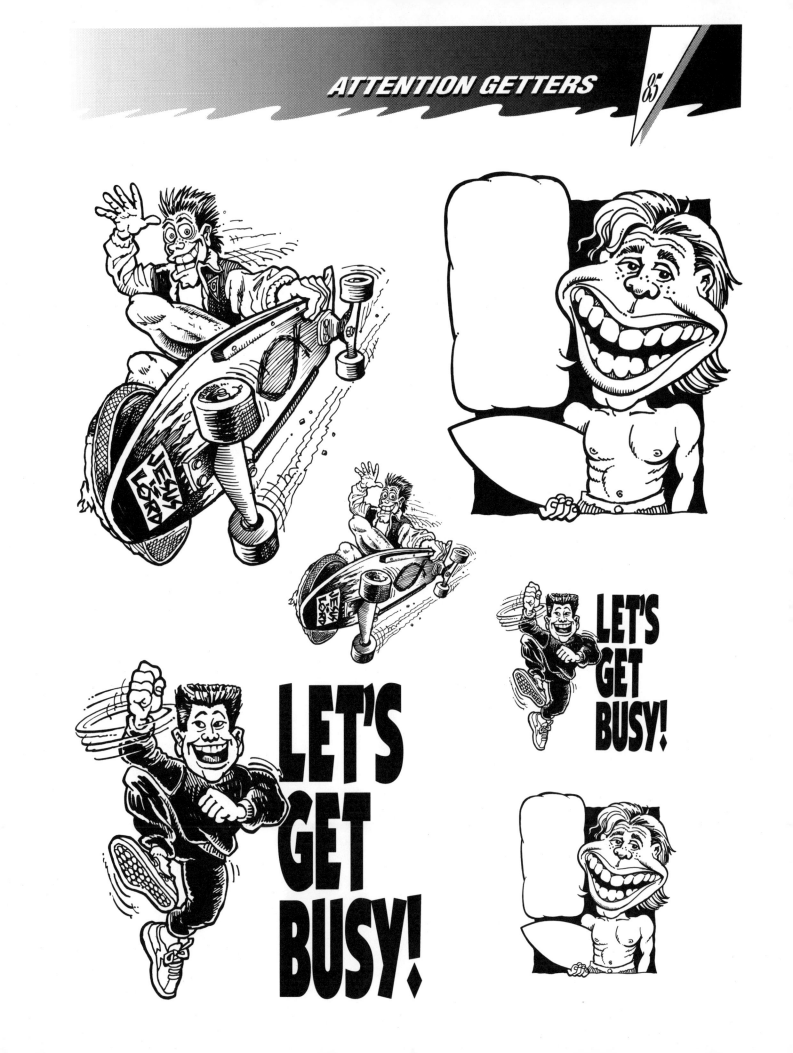

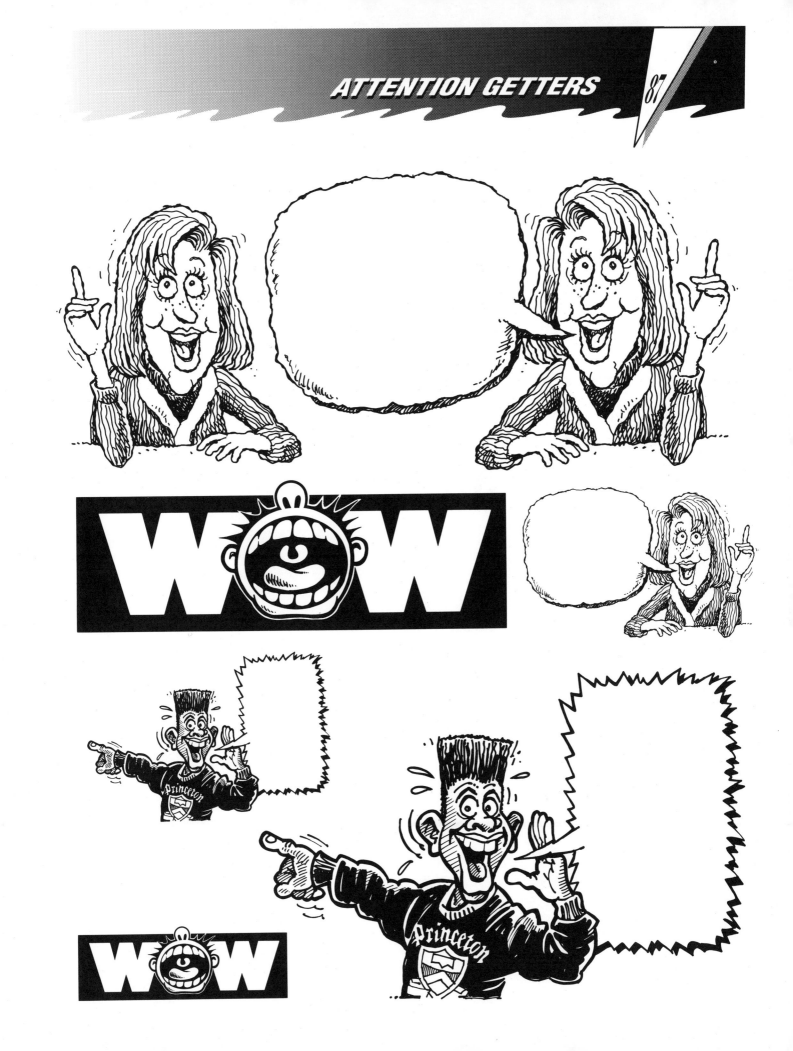

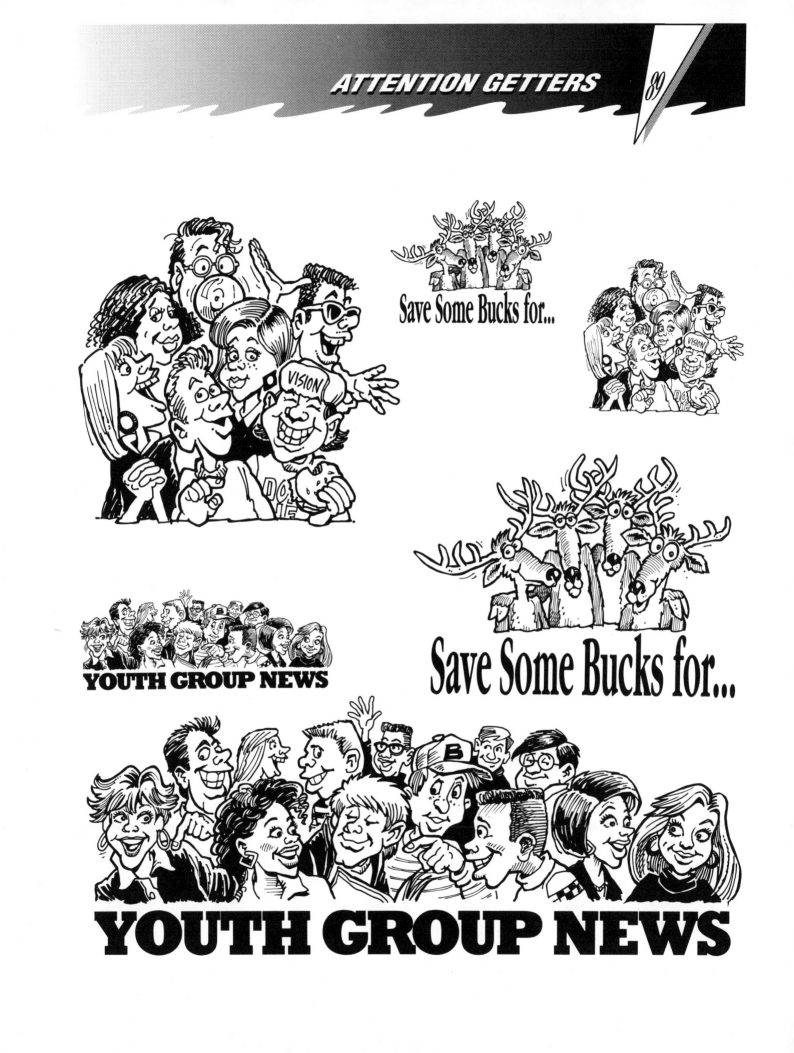

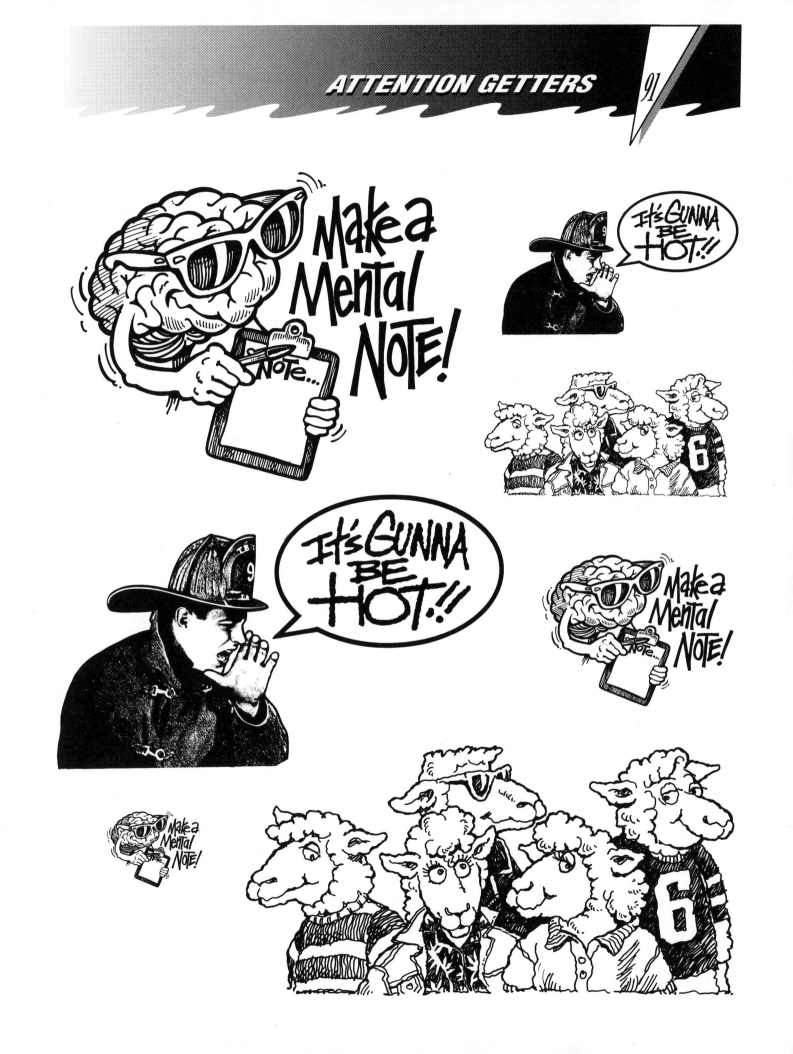

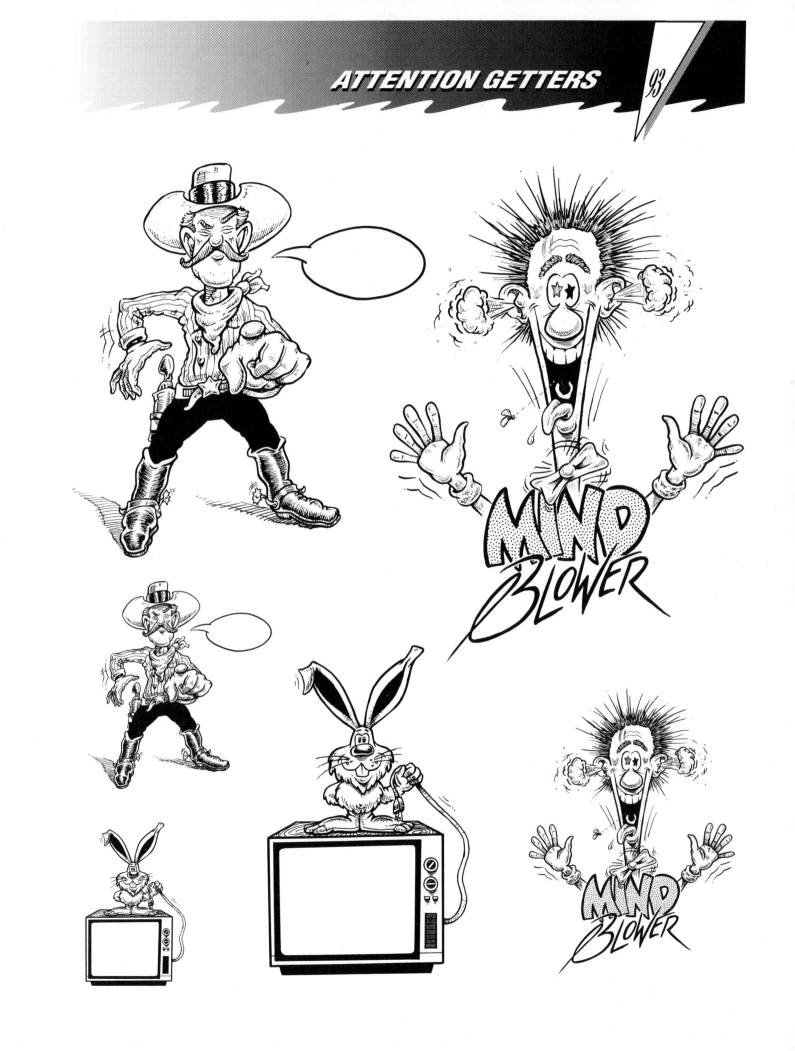

A
Abstract Art Border 25
ATTENTION GETTERS 85-93
B
Bible 61, 67
Bible Reader 53
Boom Box 67
BORDERS 15-49
Brain 91
Brick Border 27
C
Candle 73
Celebrate the Son 75
Christmas 73, 75
Contemporary Border 35
Cowboy 93
Cross 65, 67
Cupid 81
D
Dog Border 15
Dove 57
E
Easter 79
F
Face Border 49
Firecracker 83
Fireman 91
Flock 91
Food Border 47
G
Get Busy 85
Girl (Bible Reading) 61
Girl (in Sunglasses) 63
Girl (in Triangle) 59
Girls (in Group) 53
Graffiti Border 31
Group of Kids 89
Guy (in Sunglasses) 63, 65
Guy (in Triangle) 59
Guy (Looking up) 65
H
Halloween 69
Handshake 61
Happy Birthday Jesus 75
Harvest Party 71
Hearts 81
He Is Risen 79
HOLIDAYS 67-83
Holly 75

I
Independence Day 83
It's Gunna Be Hot 91
J
Jesus 55, 57
Jr. High 55
July 4th 83
K
Kids 89
Labor Day 83
Let's Get Busy 85
Lightning Bolts 61, 63
Lizard Border 29
M
Make a Mental Note 91
Mind Blower 93
Money 89
Motivation 85
Mummy 69
N
New Years 77
News 89
O
Optical Art Border 19
P
Phone Booth Jamming 65
Phone Directory 51, 59
Pilgrims 73
Praying Hands 53
Pre-Turkey Day 71
Primitive Design Border 21
Primitive Surf Border 45
Pumpkin 69
R
Rabbit 93
Remember . . . 91
S
Save Some Bucks . . . 89
Sheep 91
Shout Border 39
Skateboarder 85
Snowflake Border 37
Splash Border 33
Sr. High 55
Stupid Cupid Party 81
Summer (Beach Border) 23
Summer Fun Border 41
Sun 57
Surf Borders 41, 45

Surfer 85
SYMBOLS 51-67
T
Teen Group 89
Thanksgiving 71, 73
Tire Border 43
TV 93
V
Valentines Day 81
W
Word Bubble (Boy) 87
Word Bubble (Cowboy) 93
Word Bubble (Fireman) 91
Word Bubble (Girl) 87
Word Bubble (TV) 93
WOW 87
Y
Youth Group News 89

VOLUME 2
INDEX